MW00857131

T / AMEN PEACE / S

ABOUT UNRULY

This is the seventh book to be published under Unruly, Enchanted Lion's imprint of picture books for teens and adults. We launched Unruly because we believe that we never age out of pictures and visual stories, and that we long for them across our lives.

In his photos, Valfre captures little moments of daily life, transforming them into tales of the human condition that are by turns humorous, wondrous, and profound. By framing the ordinary as worthy of attention, *Tales from Dreamland* awakens us to just how remarkable, magical, and beautiful the experience of being alive in the world truly is, as an existential fact, even with the ever-present grief and misery.

IN MEMORY OF...

Joe Frank—friend and spoken word artist
who helped push my imagination.

Jayne Van Hoen—who gave me a show at her gallery
and encouraged me to create a book.

TALES FROM DREAMLAND

Ed Valfre

an
Enchanted Lion Book
NEW YORK

INTRODUCTION

To open your eyes each morning with a sense of wonder.
To be amazed by the patterns of first light on the bedroom wall.
To have this be how you awaken…

We take in so much visual information in a day that we often
miss the beauty of what is right in front of us. There was
a time when I thought that as a photographer, I had to travel
to exotic places to find the extraordinary. Now I understand
that I'm constantly surrounded by it; that there is a grace to
the ordinary. A shadow, a cloud, light falling on the face of a
person sitting at a café—these are everyday moments of beauty.
It's as if the world is saying, "Look at me," not from a majestic
mountaintop, but from the cream swirling like a galaxy in a
cup of coffee.

This is the ordinary magic of the everyday that asks us
not just to look, but to see—with the eyes, the heart, and
the imagination, and to know that this world, our world,
is one that holds infinite possibilities.

Ed Valfre

In this place where we live,
something magical happens
every day.

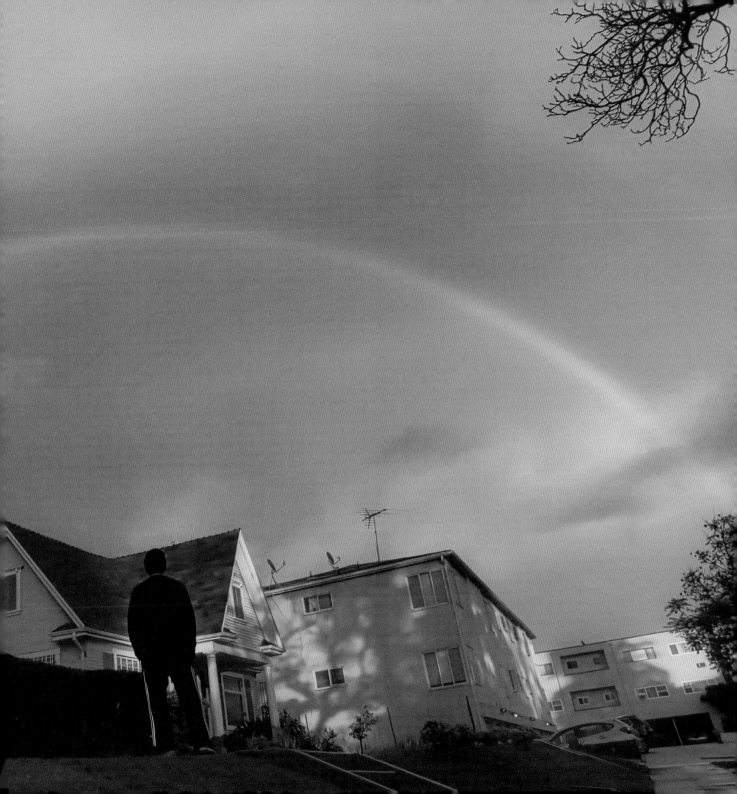

MOMENTS of
BEAUTIFUL LIGHT

*How could sunlight look so beautiful
in such a drab little room,* he thought...

He had been sleeping in cheap motels as he
made his way to California. He had left his
home in Texas, searching for a new place that
felt right. But as he would come to understand,
it was in these moments of beautiful light
that he felt most at home.

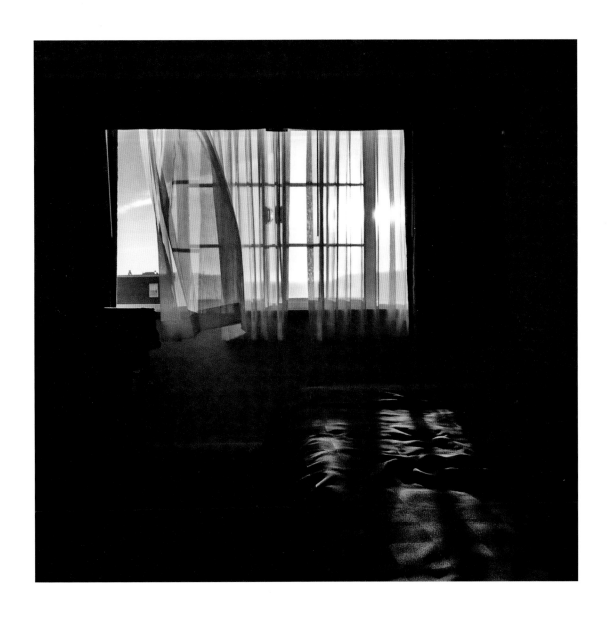

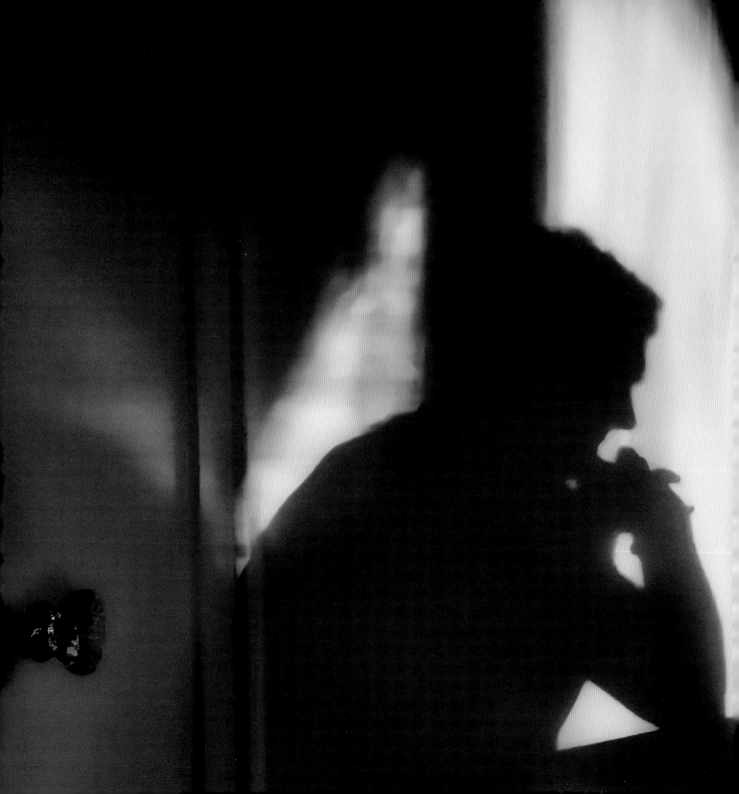

DISTANT SOUNDS

The sounds of the baby crying and of the next-door neighbors fighting over burnt toast, the booming construction noise down the block, and the chitter-chatter of his wife's conversation about a person whose name he didn't know went through him like neutrinos passing through the Earth. He would finish his coffee and drive an hour through the desert to his job at the radio telescopes. There, he would fix his complete attention on the sound of distant stars, quiet with their beauty and mystery.

FOUND

Every day at sunrise, the shadow of a boy
would appear on the same wall. It was
just a shadow, there was no boy. Many
tried to explain it as merely an optical
illusion. No one really knew. Then one
bright morning, the shadow didn't appear.
Where it had gone was a mystery. Some
were sad, but what they would never
know was that the shadow had finally
found the boy.

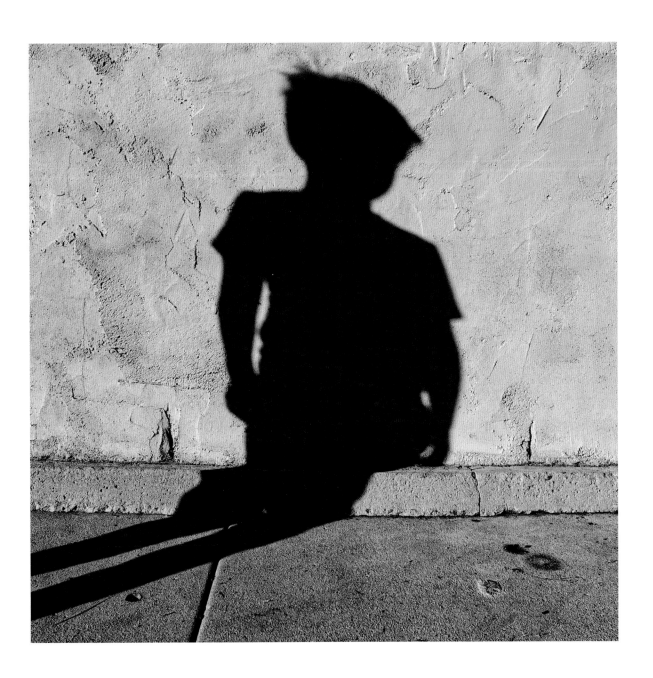

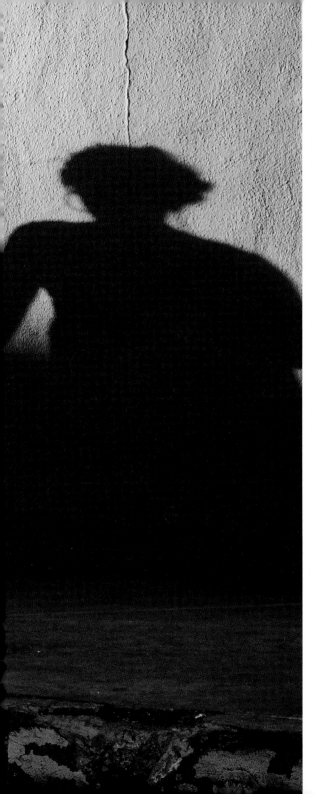

NOBODY NOTICED

There was once a woman who was only a shadow. She walked through the busy streets and nobody noticed. As the light changed, so would she, until at some point in the middle of the night, she would disappear, only to return in the early hours of the morning.

LEVITATION

As a young boy, Carlos Sandoval discovered that he
had the ability to levitate inches above the ground.
He could literally float around his room, but only
when his mind felt unburdened. The last time he
was able to do this was when he was twelve years
old, on the occasion of his first kiss with the girl who
lived down the street. As time went on, the weight
of the world began to hold him down. He had now
been earthbound for sixty years. At the invitation
of a friend, Carlos attended a concert in the park,
where he danced all night with a beautiful woman.
As they parted, she kissed him on the cheek, and
on that night, Carlos floated the entire way home.

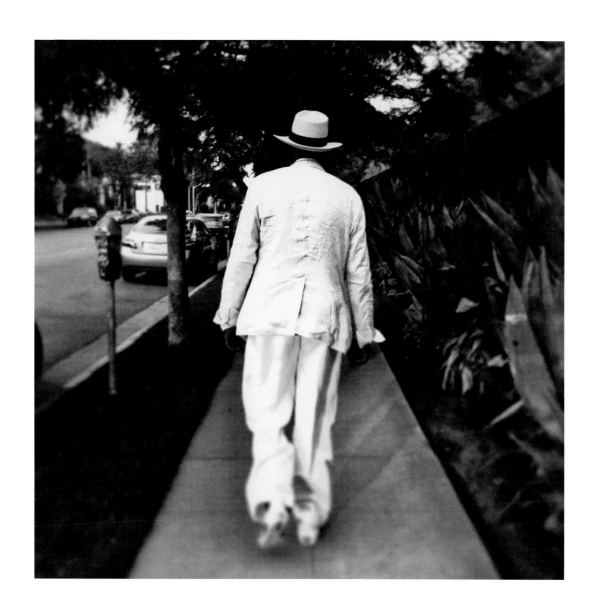

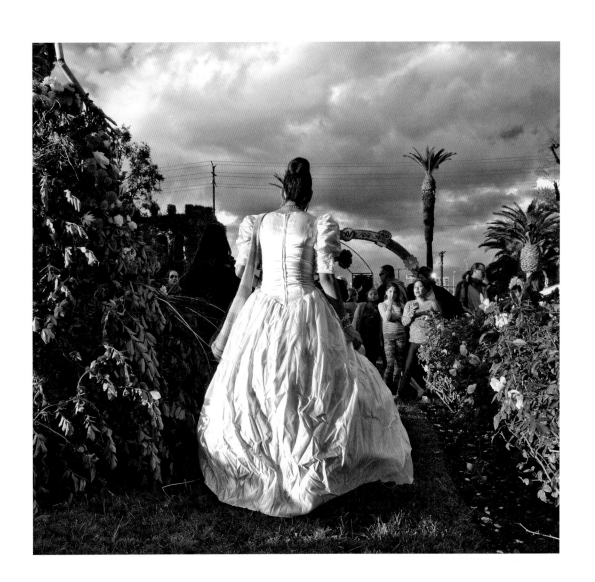

The MAGIC DRESS

There had been a rumor that the woman living at the end of Willow Crest Road was a witch. Margaret was her name. She rarely left the house or talked to anyone. She simply liked the quiet peacefulness of her own company. Local children would sometimes yell mean things from her front lawn, or leave a cruel note on her door. One afternoon, Margaret went to the closet and pulled out her mother's magic dress. "When you wear it, the world sees you differently," her mother always said. Margaret walked out the front door and down the street wearing the dress for all to see. Now there is a new rumor that the children believe: the lady living at the end of Willow Crest Road is a queen in hiding.

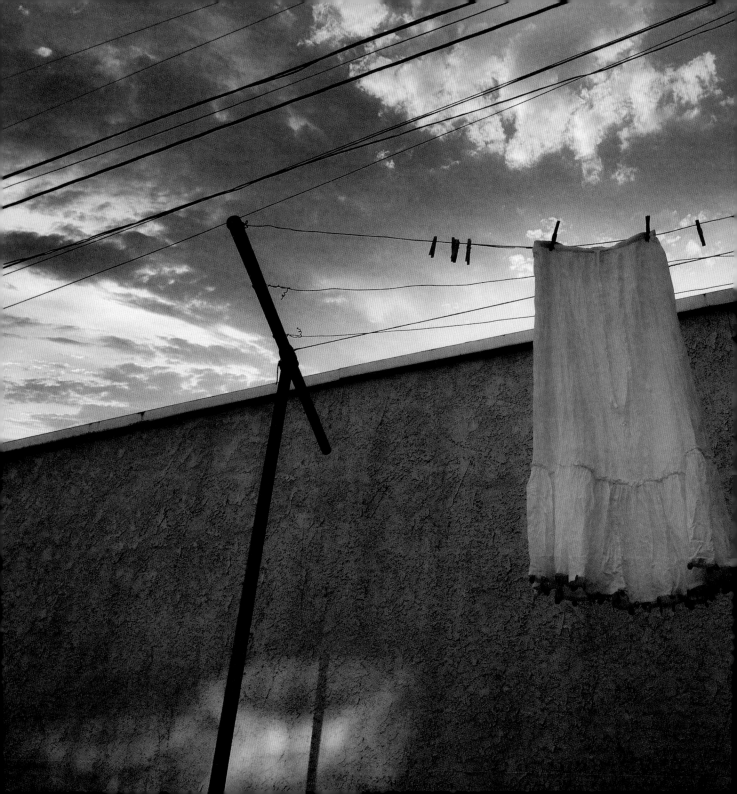

GHOSTS on the CLOTHESLINE

It had been several months since she had left him. In the backyard, her forgotten skirt still hung on the clothesline, like the ghost of lost love.

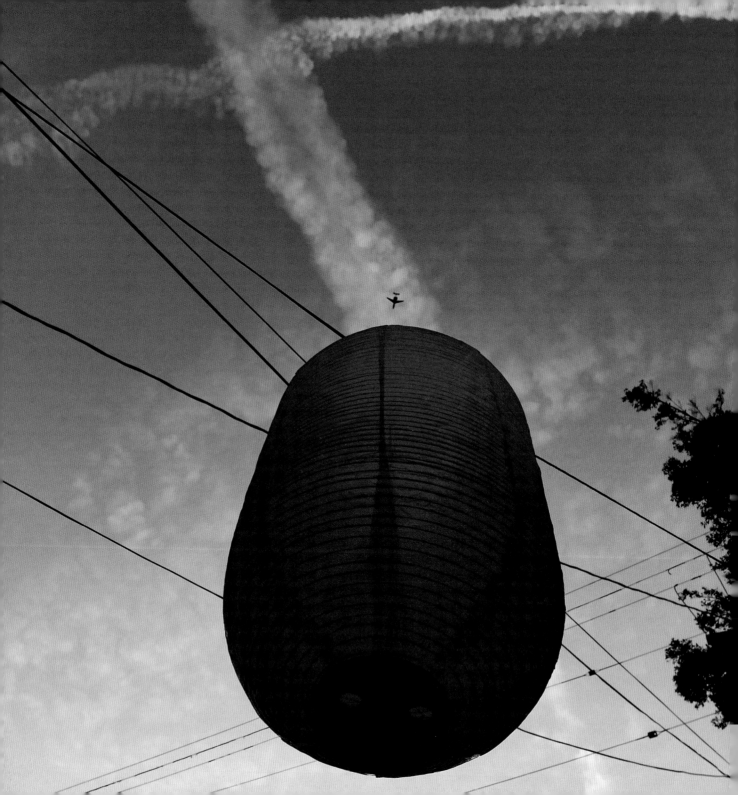

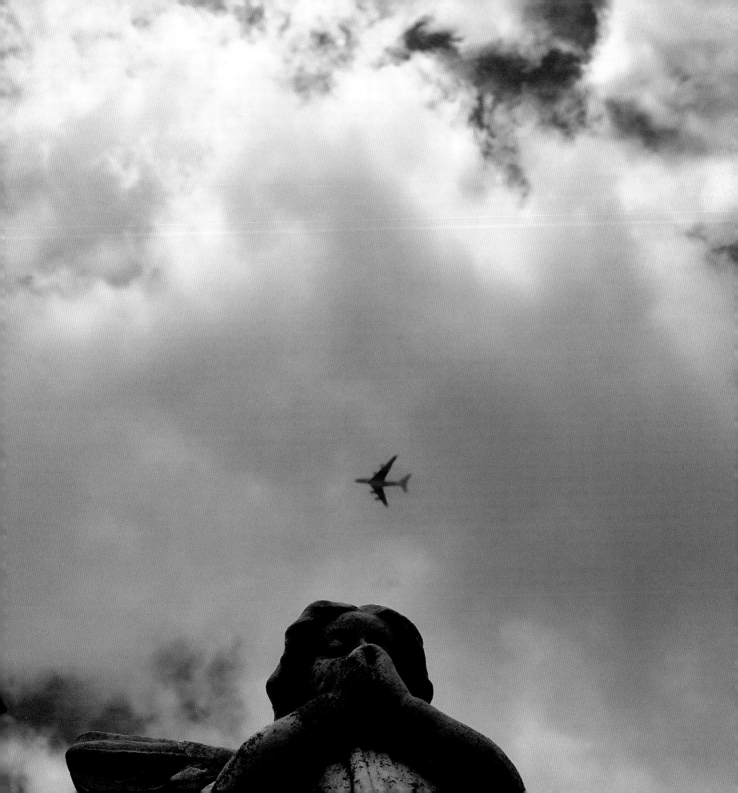

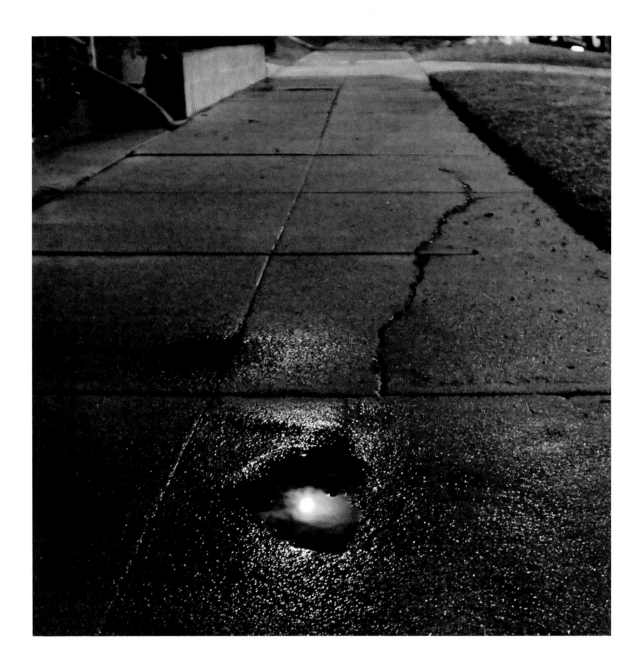

The NIGHT
the MOON FELL

The night the moon fell from the sky was a sad night. Everyone searched and searched, but the moon was nowhere to be found. A great melancholy covered the world that dark night. Lovers, coyotes, and astronomers were all in a state of sorrow. Then, while on my evening walk, I saw it: the moon had fallen into a puddle. So I pulled it out, dried it off, and flung it as hard as I could back into the pitch-black sky. The coyotes howling in the distance that night had never sounded so good.

LUNCH
in the CLOUDS

Every day at noon, he would rush to his favorite table, the only one with a glass top that mirrored the clouds. While his coworkers talked of ordinary things, Wilson O'Brien was riveted for a brief moment during which his ham sandwich, banana, and cup of coffee seemed to float magically across the lunchtime sky.

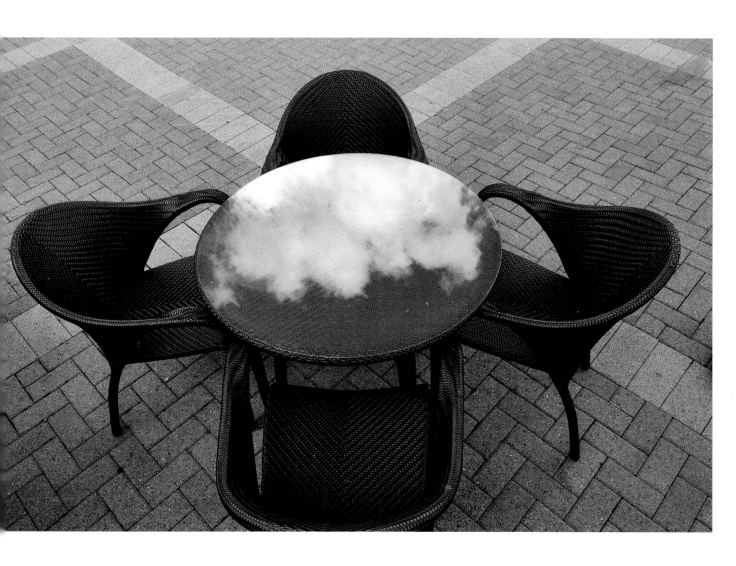

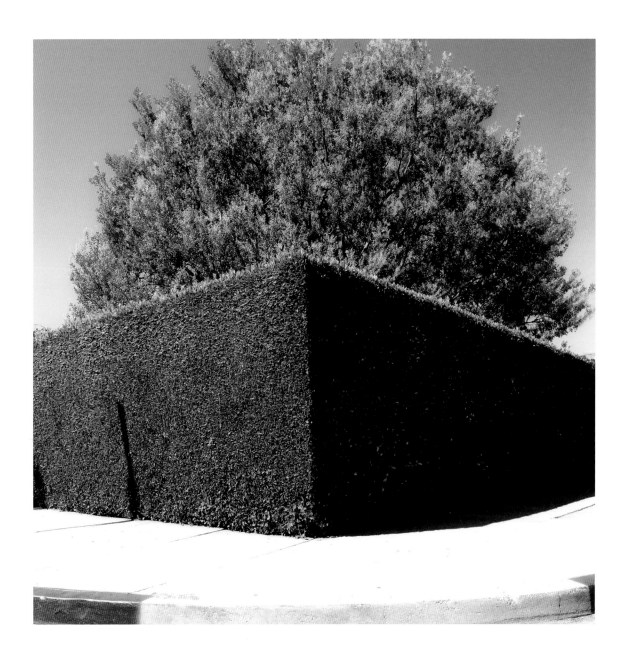

PERFECT NATURE

Hampton Crawford had long admired his neighbor's front yard. The trees, the hedges, and even his pets were trimmed to geometric perfection. One day while passing the yard, Hampton decided to peer into the hedges. Inside was a tangled mix of branches, leaves, and insects. *It's really chaos in there*, he thought. Later, as he was about to go out for the evening, Hampton looked in the mirror and admired the well-groomed appearance of his hair and clothes. He then thought of the perfect hedges and wondered if anyone could see the chaos within him.

COFFEE
or OBLIVION

In some distant place in the universe, an entire galaxy was pulled through the event horizon of a supermassive black hole. Somehow, it landed right in the middle of my morning coffee. One alien civilization desperate to survive sent me encoded messages, broadcasting: "We are here. Save us." It was difficult not to drink that first cup of coffee, but the planet that once circled a star in the Pinwheel Galaxy now rests safely on the upper shelf of my kitchen cupboard.

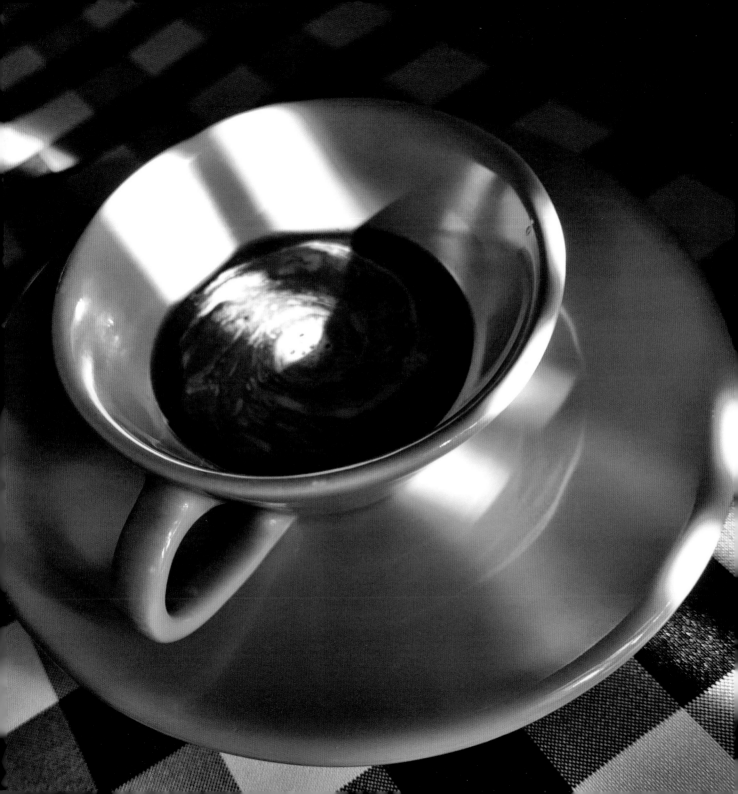

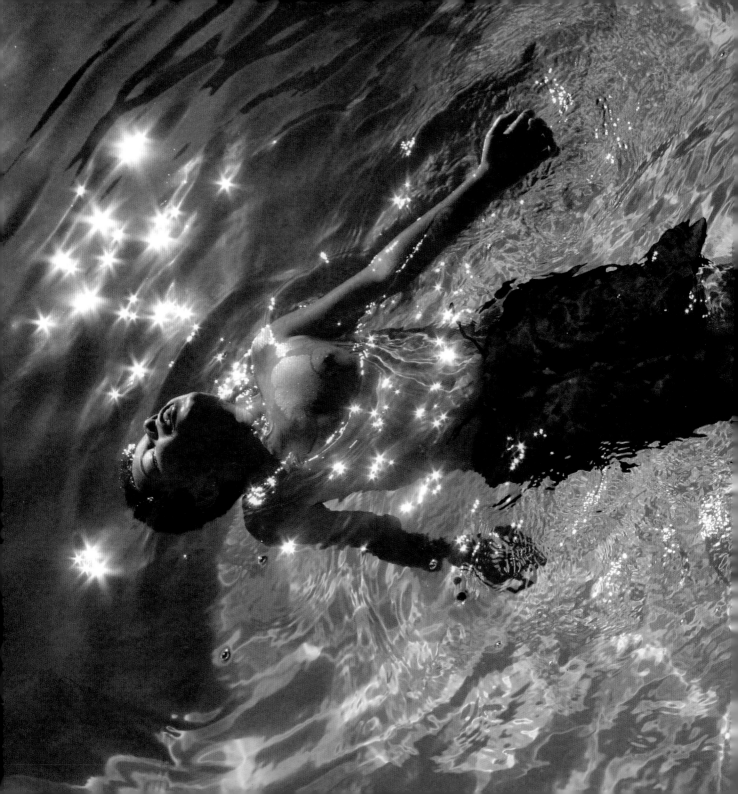

The FLOATING WORLD

Floating in the water,
looking up at the clouds,
his mind went through
a hundred scenarios that
led nowhere. After a while,
there was only the sound
of his heart beating.
It was a perfect moment.

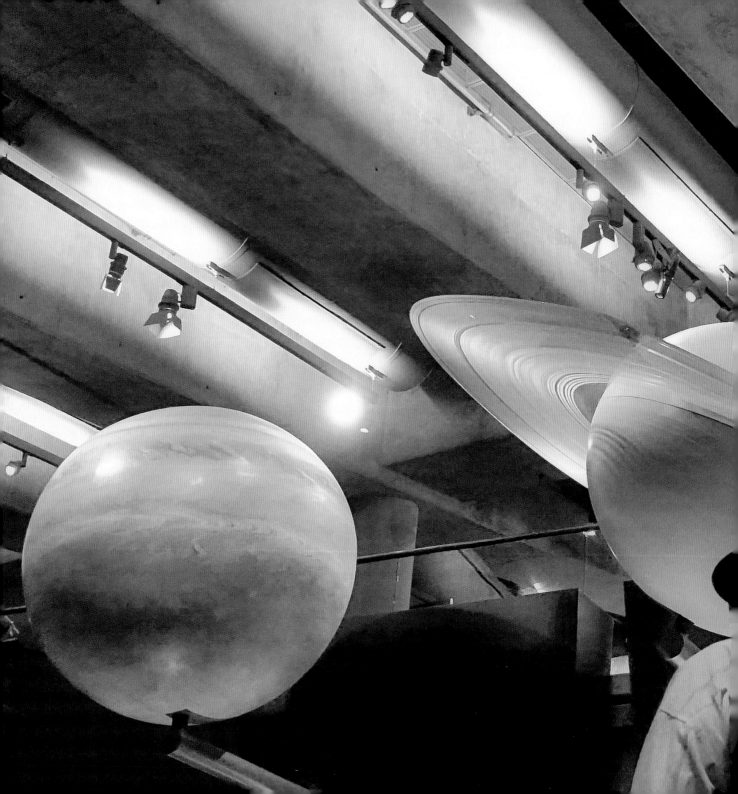

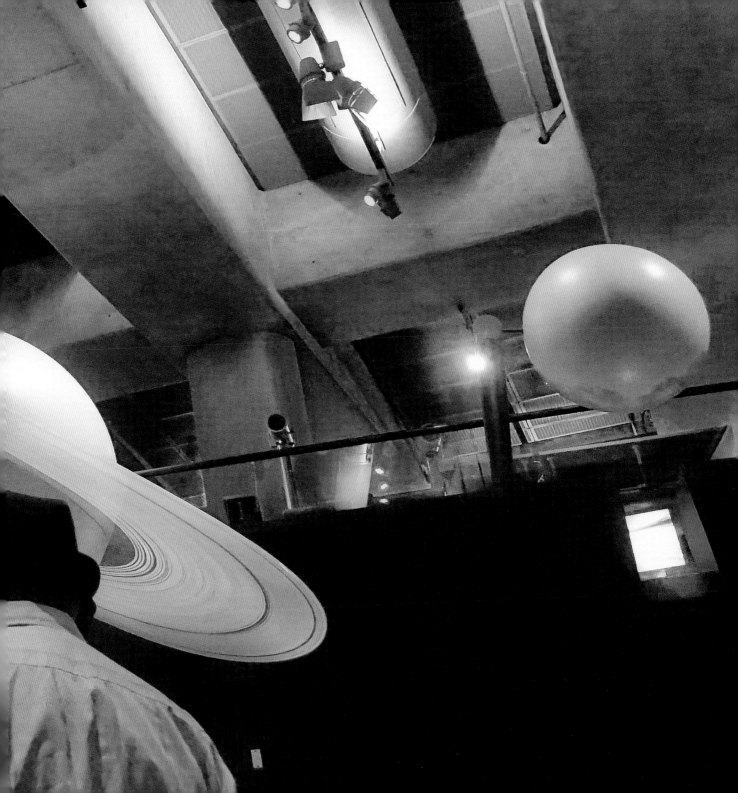

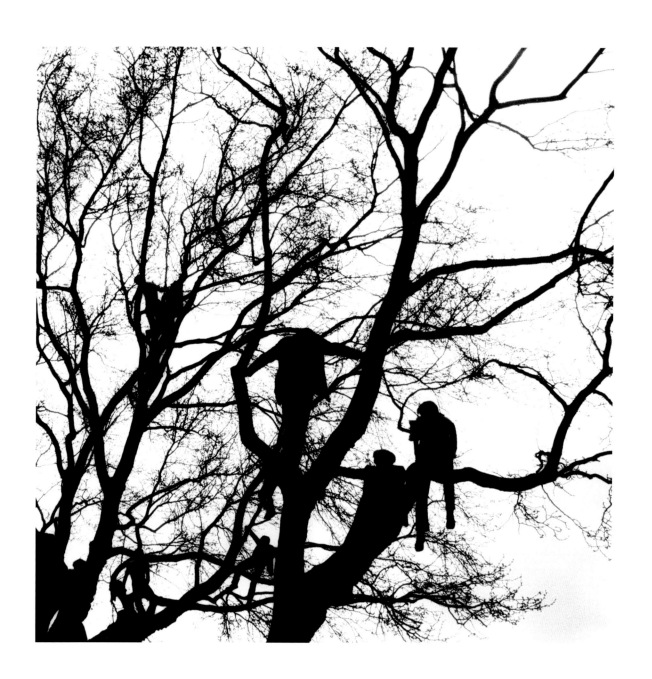

The LOST FATHERS

When I was sixteen, I had a dream about my father.
I hadn't dreamt of him since his death two years before.
In the dream, I am returning from school when I see
my dad standing high up in a tree in front of our house.
I ask why he left and where he's been these past two
years. "I decided to live up here in the trees. It's really
quite beautiful, and there are many other dads to talk
to," he said. I told him how much I missed him and how
I also needed to talk with him. "I miss you, too, son, but
I watch you every day," he tells me. Now, years since
that dream, I look up at a glorious tree and think
of the day when I will join him, and we will look down
at my own son.

The LAST PHOTO

It is my favorite photograph of my
father. He was examining a plastic
camera. My first. I was thirteen.
The picture was an accident, but it
is the very last image of him ever
taken. A few months later, he was
dead. Now, when I look at this final
photograph, I can see my entire
time with him captured in one
accidental moment, when I still
thought that the people you love
lived forever.

STUDERS OF TEXAS

DEC

64

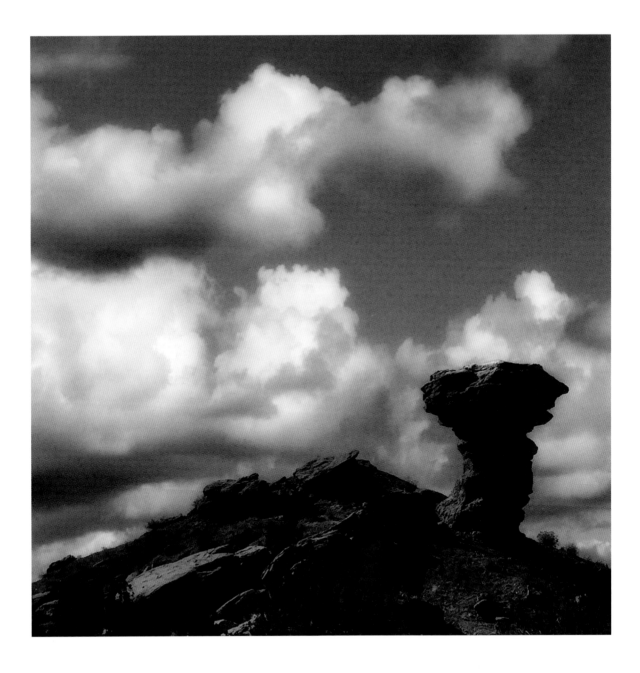

MEMORIES of
CAMEL ROCK

We were two brothers climbing Camel Rock
while on a family road trip through New Mexico.
I was six and my brother was thirteen. He was
officially a teenager and considered me the pesky
little-kid brother, but on that day, as we climbed
Camel Rock, we were both somehow equal.
We were both explorers in this land of magical
rocks and sky, and he reached out his hand to lift
me to the highest point. All these years later, my
brother now gone, there are fences surrounding
the place we used to climb. The rock, we are told,
can only be observed from a distance. But even
from the distance of time and death, I can still
feel the hand of my brother reaching out to lift
me up to the next level.

The PEACOCK

When I was a kid, I used to visit my grandmother's grave at the cemetery. I would put flowers in a vase, sit for exactly twenty-five minutes, and have my lunch of a tuna sandwich and a soda. One afternoon, a peacock approached me inside the nearby mausoleum. He pranced right up to my face and said, "If you were really a caring person, you'd have brought another sandwich." Then he walked away in disgust. The next time I visited, I brought a second sandwich with me. "What, no soda?" the peacock remarked.

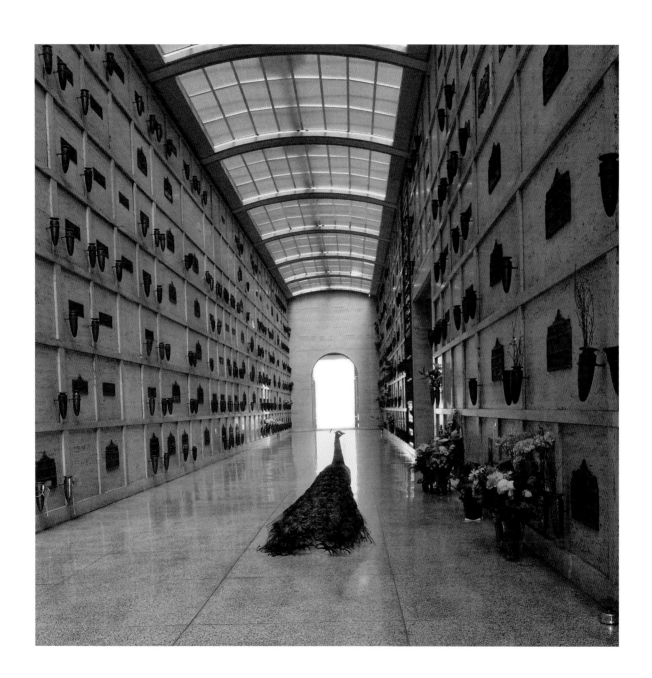

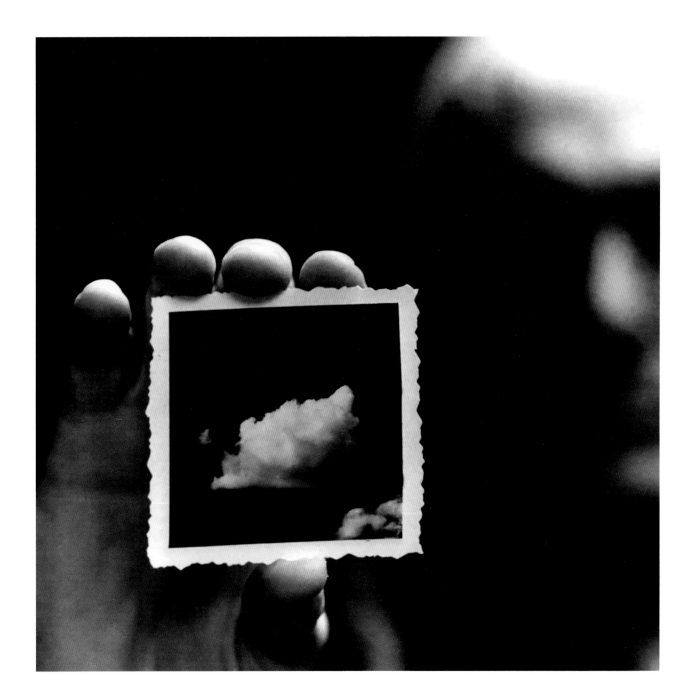

FOR EMERGENCIES ONLY

He kept it in his pocket for the times
when he got too frustrated or angry.
He would only use it in emergencies,
when he felt like giving up. It's strange,
the little things that give you hope.

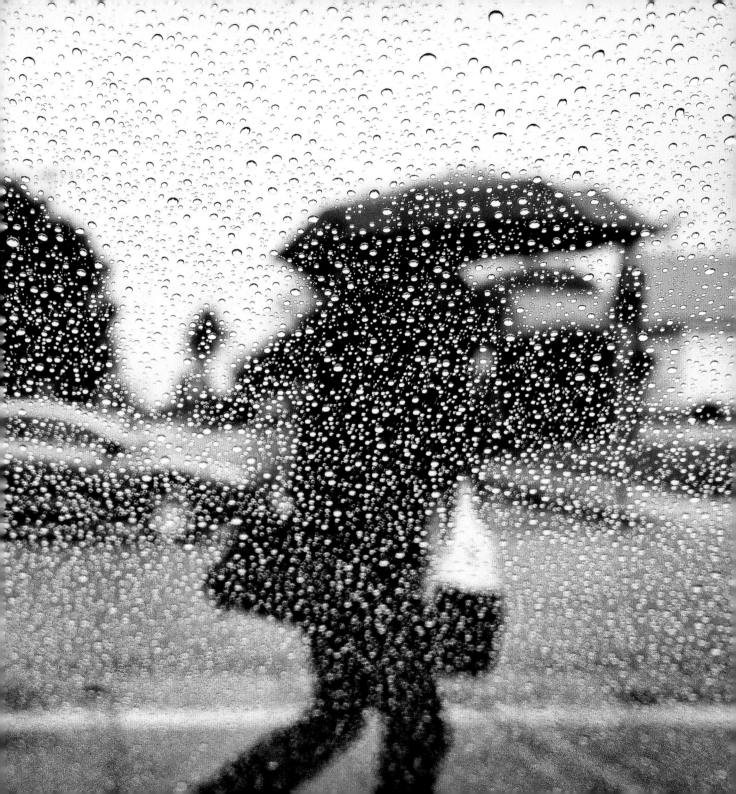

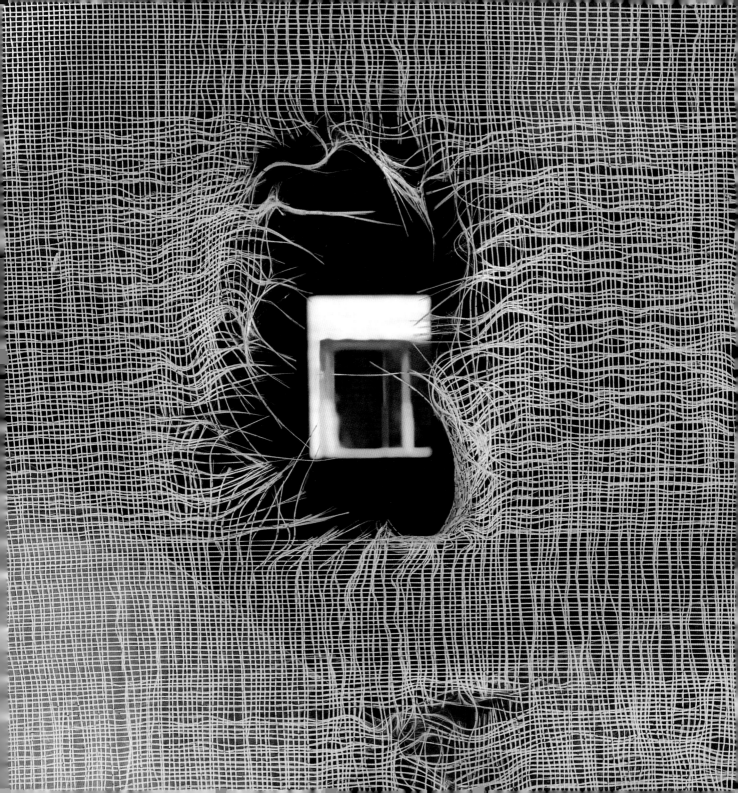

WOLF in
the HOUSE

Moments before falling asleep for an afternoon nap, I noticed a wolf entering the house, who then spoke to me. "You have lived many lives, my friend. You have been man and woman, rich and poor, a genius and a fool." "Really?" I said. "No," said the wolf. "I'm just messing with you. This life is it. Now get off the couch!"

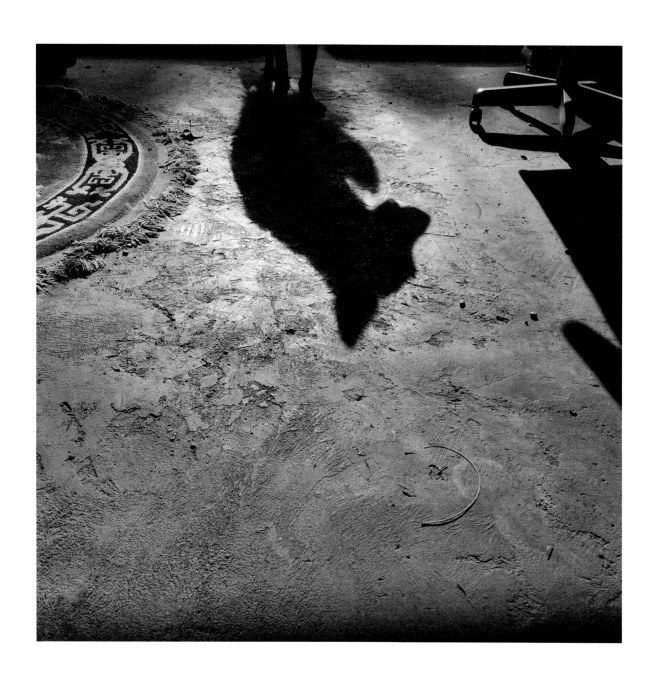

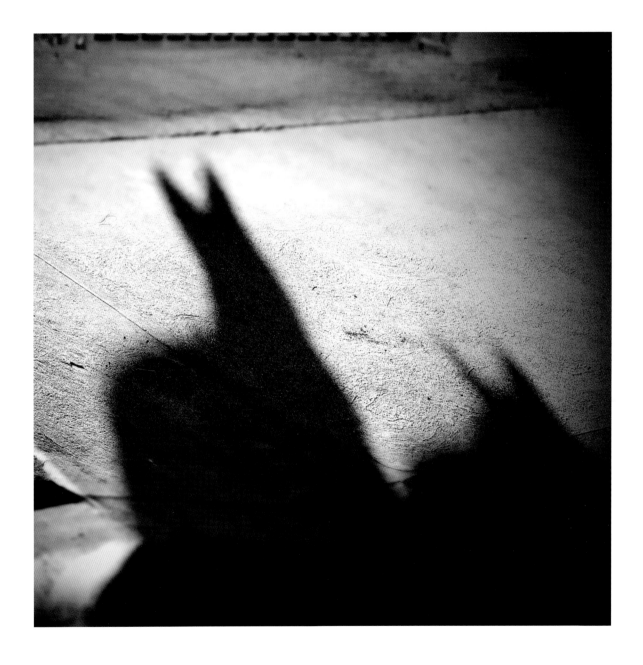

JUST TWO
ORDINARY DOGS

They were not superheroes, just two ordinary
dogs who happened to save planet Earth. It was
a fortunate set of circumstances when the first
scouting spaceship landed in their backyard.
It was even more fortunate for Earth that the
evil aliens resembled their favorite squeaky toys.
Shortly after the encounter, the dogs went back
to chasing their own tails around and around,
never knowing that they had just saved everything
they loved. But dogs are like that.

RIDING MOON

Valerie's horse, Moon, was the perfect listener, often staying still through the girl's soliloquies about the sad state of her teenage life. On this afternoon, the horse seemed determined not to listen, interrupting her with various snorts and neighs. Moon kept moving away from Valerie's attempts to talk and finally settled near the saddles. "So you want to ride?" the girl said. As they rode over the hills, Valerie's angst was no more than a distant memory. For a moment, she knew what Moon knew: *sometimes you just have to move.*

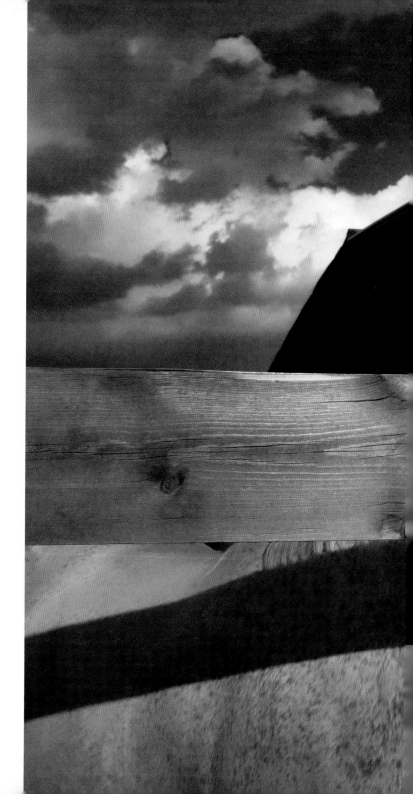

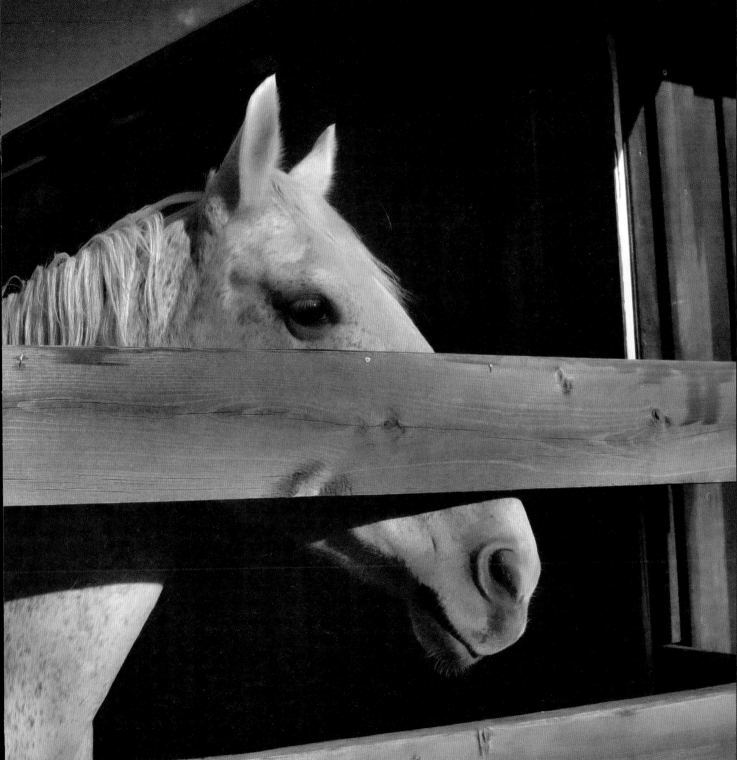

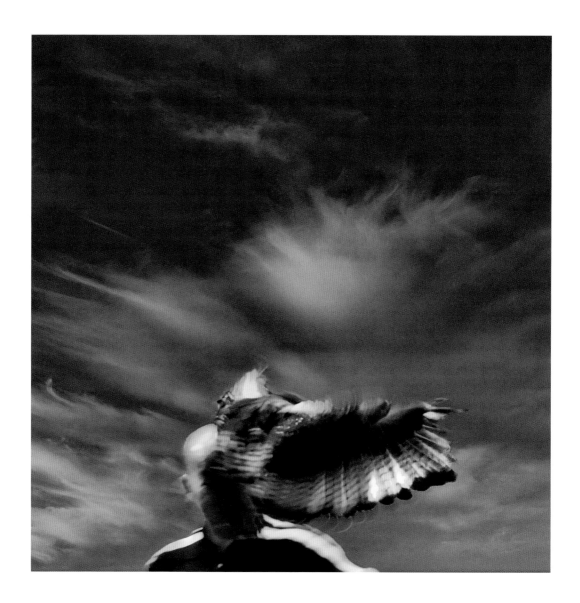

BIRD
and MAN

Some people want the loyalty of a dog or the comfort of a purring cat. Some keep fish or a turtle in little containers to watch in their homes. Hideo wanted something more. He wanted something that would transport him out of the routine of his monotonous life. He decided to raise and train a hawk. His friends would joke, "Are you taking your bird for a walk?"

"Yes," he would say, "a walk in the sky."

A NEW KIND
of CREATURE

At the end of a long day, the street peddler felt a sadness as he walked home. It seemed to him that many in this new country looked at him without seeing his humanity. *I have become a creature*, he thought to himself. And to the children who saw him that day, he was indeed a creature, but a fantastic creature made of toys.

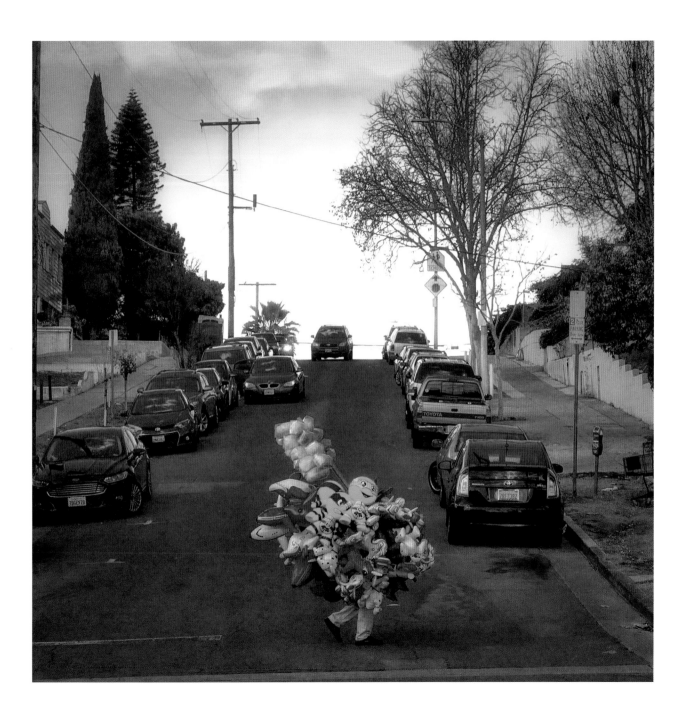

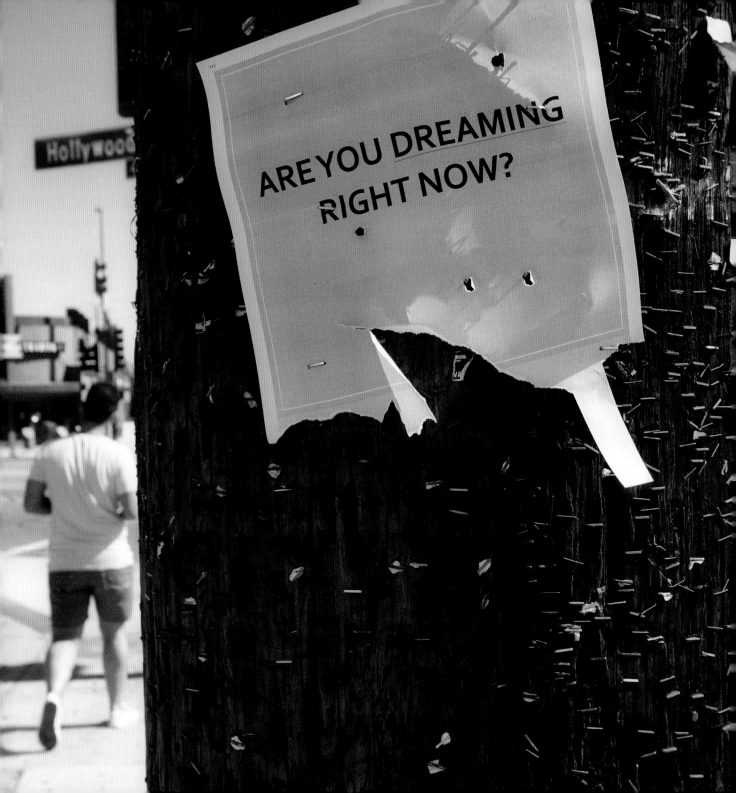

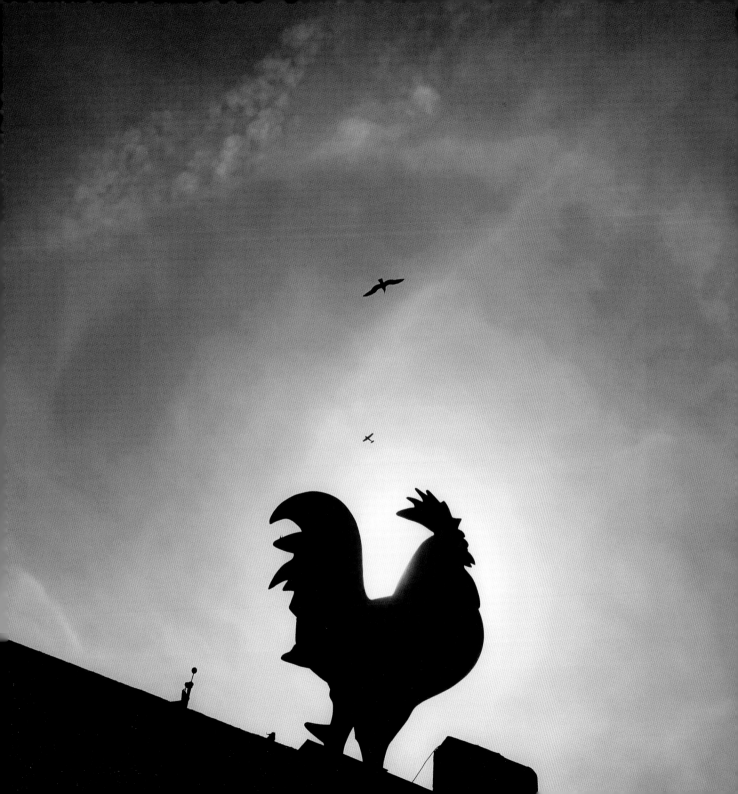

The SECRET LIFE of a SHOPPING CART

There was once a shopping cart that wanted to see the world. The grocery store workers often found it out past the parking lot or just down the street. They always returned it back to the rack with the other carts. Then one day, it made it so far that the workers gave up looking for it. Just blocks away, it began a completely new life. It kept company with a homeless man for a while, serving as a carriage for his dog. It was a wagon for some young kids for a few days, and it was even used as a camera dolly for a student film about zombies. It led a life filled with adventure, until a truck returned it back to the store. There, amidst the other carts, it told stories of the world outside the parking lot. The next morning when the store opened, all the carts were gone.

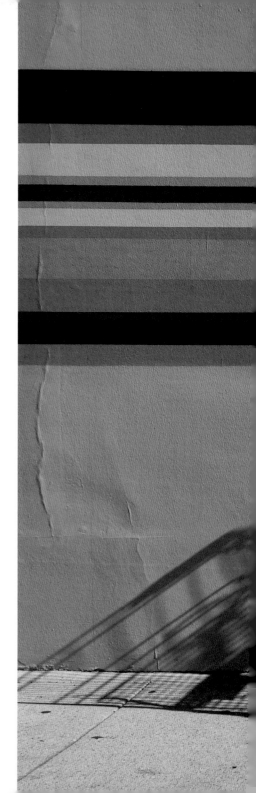

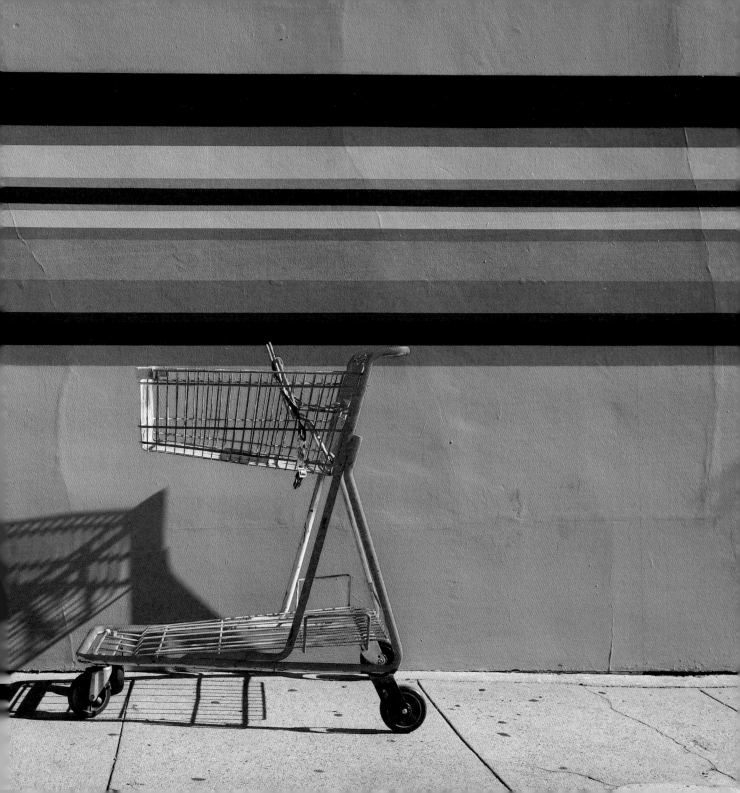

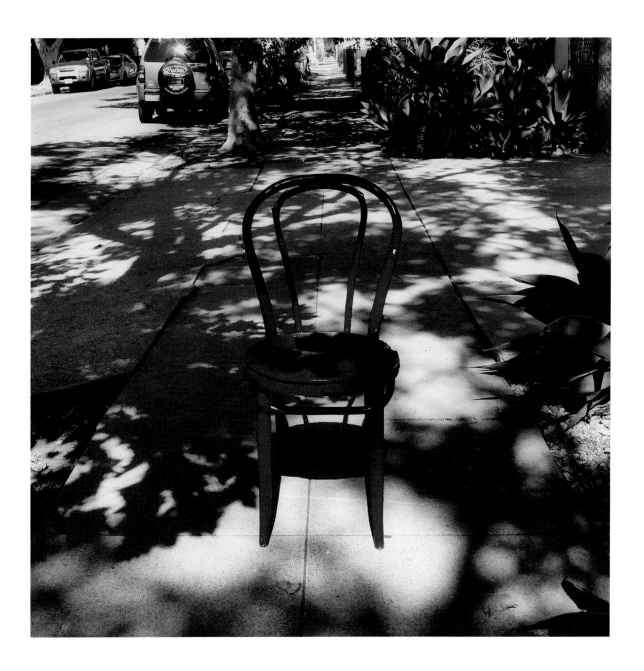

The RED CHAIR

I was walking my dog Lucky when we came upon
a red chair in the middle of the sidewalk. We decided
to sit down and were immediately transported to
another dimension, where a giant battle was in
progress. In this strange world, squirrels were leading
an uprising to become the overlords of the planet.
I made my way back to the chair so we could return
to the safety of home, but Lucky wanted to stay
in this alternate universe. I could see by the dog's
expression that here was where he was meant to be.
His entire life chasing squirrels had led him to this
moment. Some time later, I returned to the chair
and to the other dimension, so I could check on the
dog. There were statues of Lucky everywhere. He had
become the hero of the Great Battle of the Squirrel
Uprising. But despite his fame and glory, Lucky
wanted to come home. He claimed he missed his
favorite ball, but I knew better.

The MISSING
SOCK DETECTIVE

I am a private detective of missing socks. One night, a distressed sock came into my office worried about her partner, who had last been seen lying on the bedroom floor. The pair had had a little argument, and the next thing she knew, he was gone. I finally tracked down the sock in Chinatown, but I was too late: I turned him over and found a hole the size of a penny right through his sole. Yeah, he was real gone all right, and something didn't smell right. You never get used to this sort of thing. It's the reason I no longer handle lost mitten cases...It's just too sad.

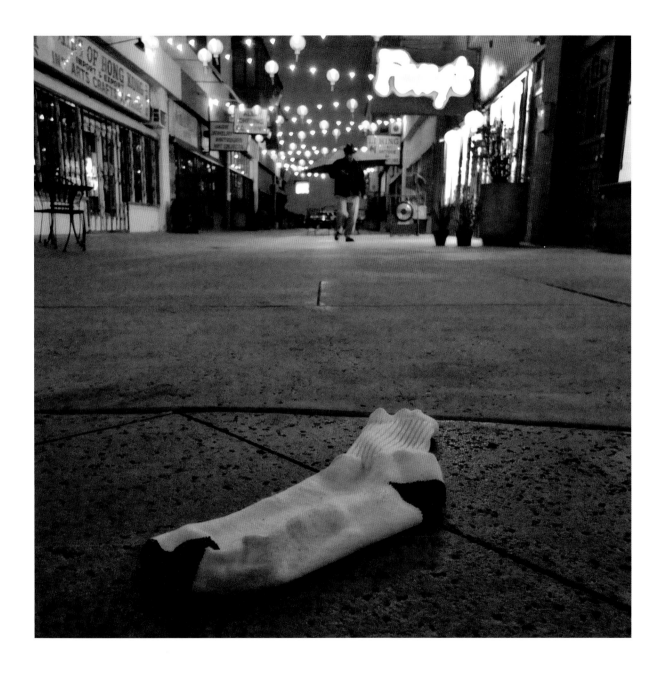

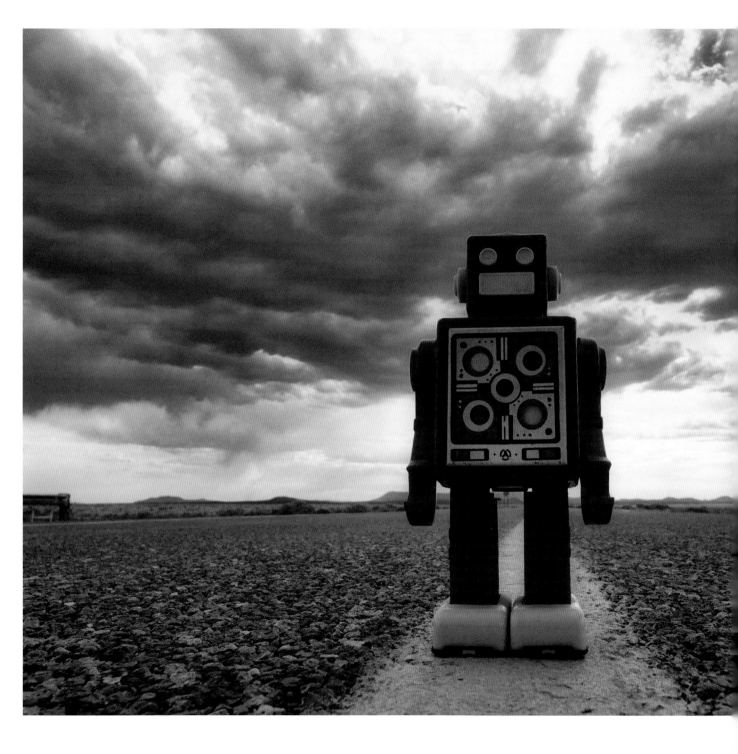

The STORY of a TOY ROBOT

Somewhere west of Lubbock, a toy robot was accidentally left at a roadside attraction. He knew the journey would be difficult if he were ever to find his way back to his boy. A great black bird carried him halfway across the desert and gently dropped him off just outside Barstow. Birds can be kind, but Barstow is about as far as some birds are willing to go. From there, it was a series of adventures involving prairie dog cities, fast food drive-through clowns, a lost one-eyed cat, and a drifter named Lenny. There was great joy and surprise when he finally got back to the boy. The toy robot would never forget the kindness of those strangers who stopped to turn his windup key on the long way home.

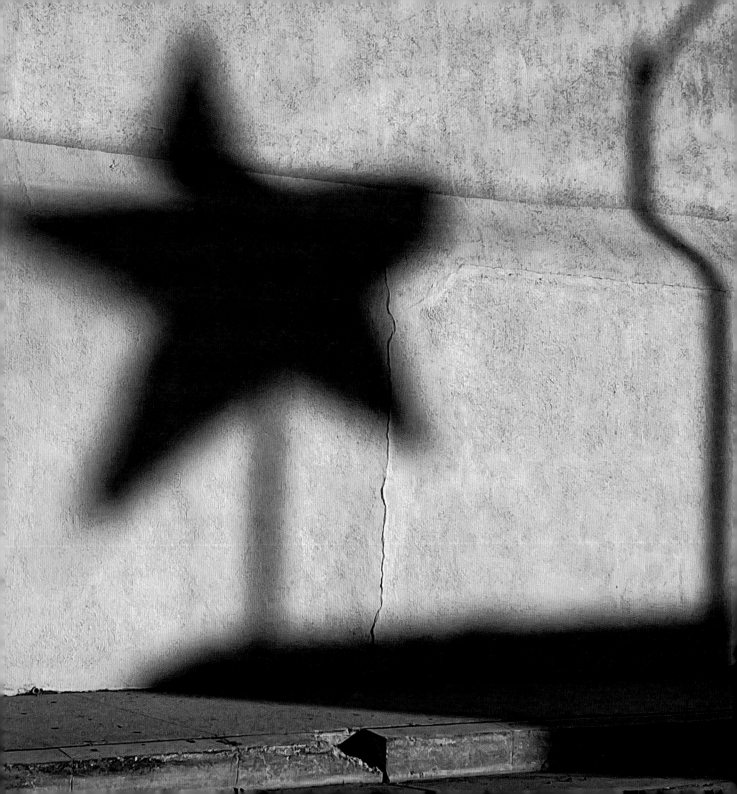

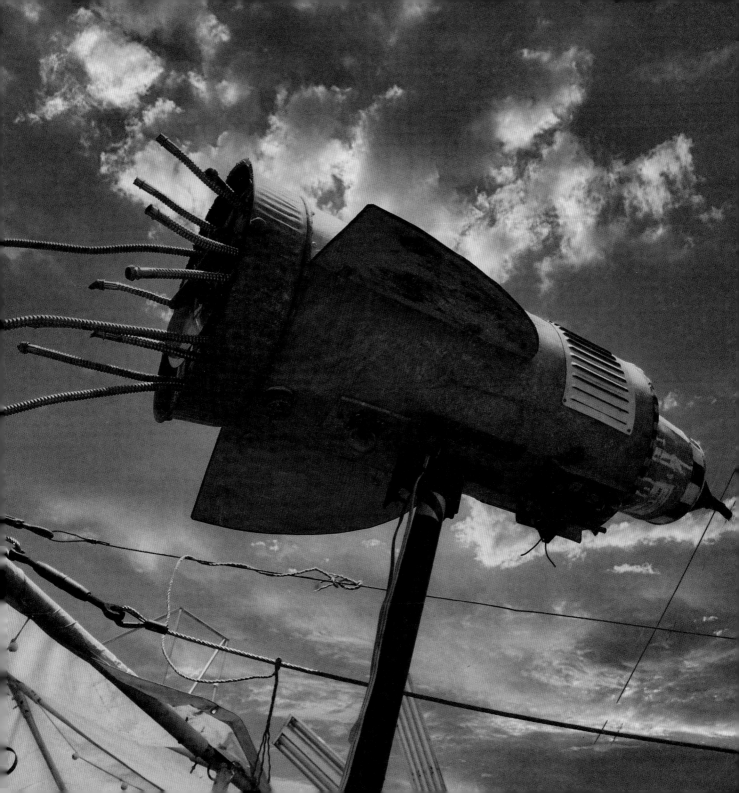

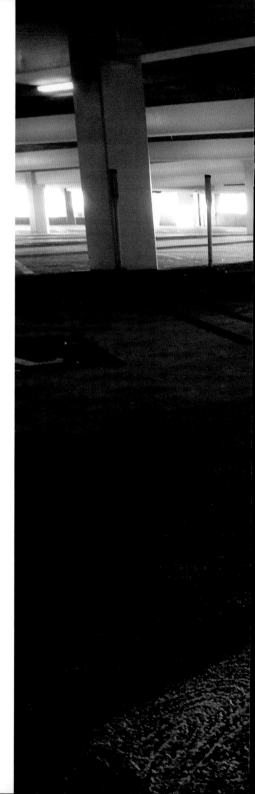

VALIDATION

The parking lot was so empty that a certain sadness overcame me. I suddenly felt alone, and that my life had not been as I had envisioned it when I was younger. I drove down the spiraling exit to a tiny glass booth, where a robotic voice told me I needed to be validated. *So true*, I thought.

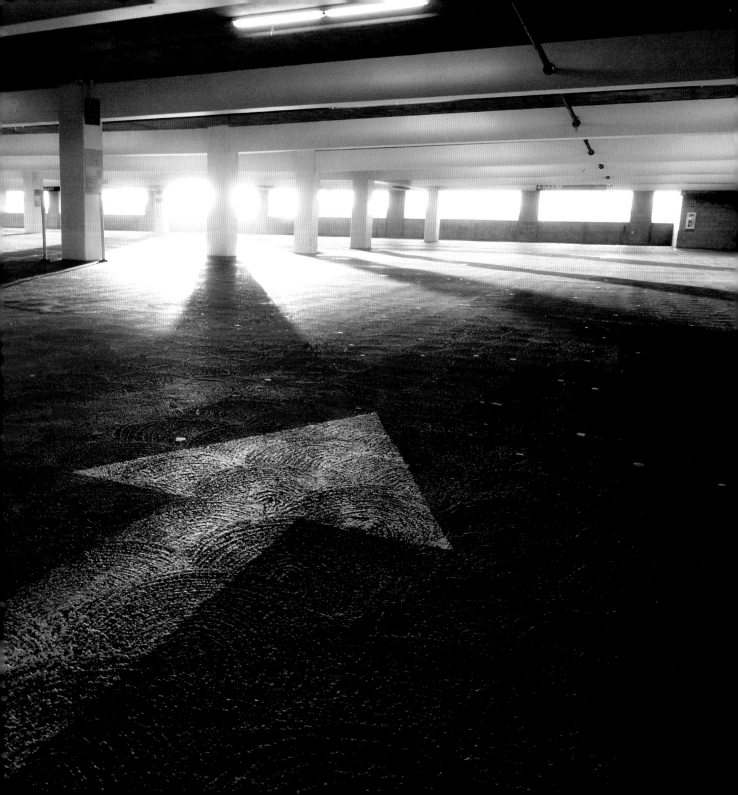

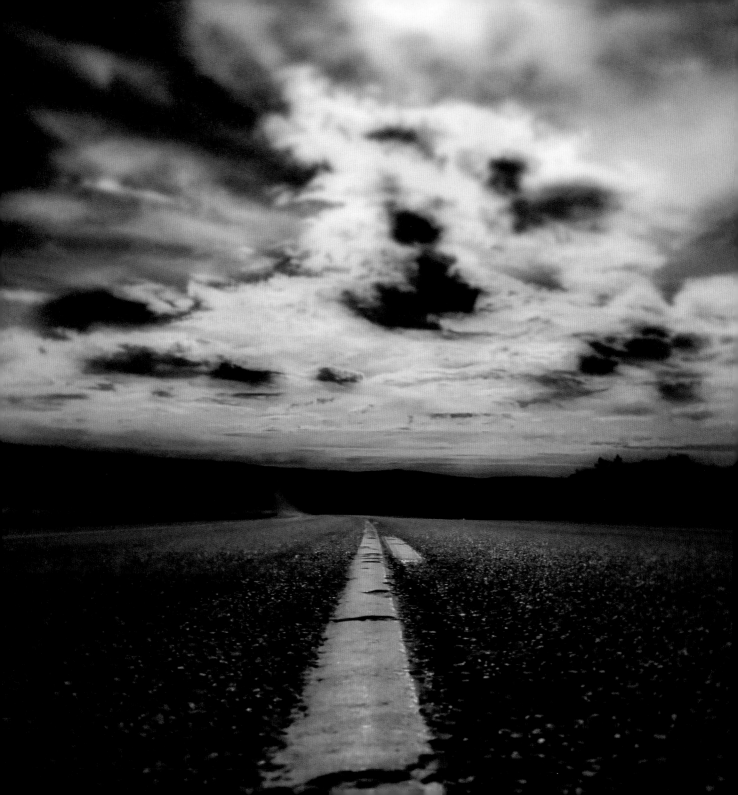

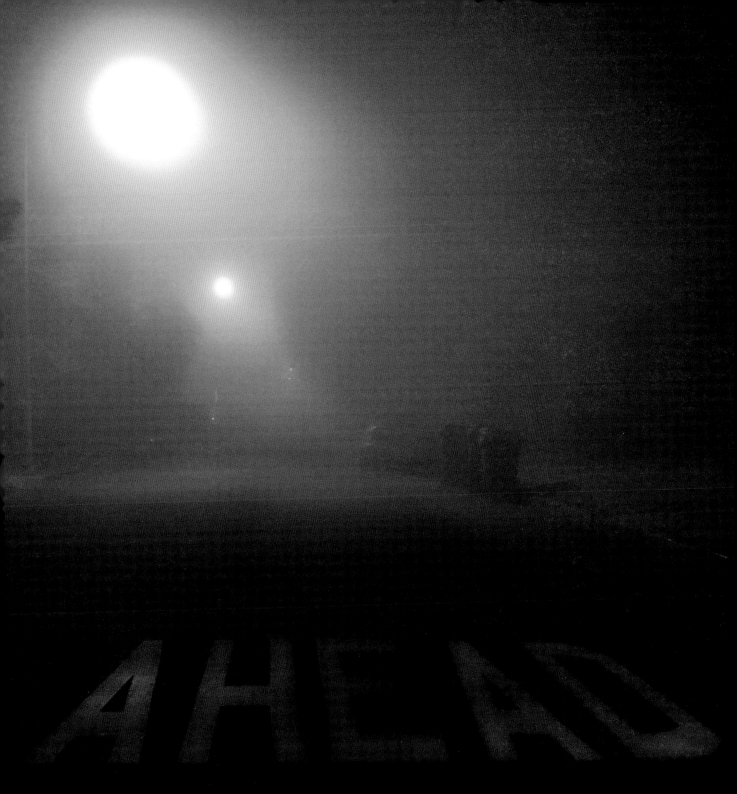

WHEN TIME STOPPED

One day, time just decided to stop. Babies
never got older and old people never died.
If you had a cold or a headache, you had it
forever. The lucky ones were stuck in the
beauty of a first kiss or the thrill of being
born. Everything in the universe was stuck
at one exact moment. Then time started up
again. Suddenly, everyone was in a rush to
get somewhere. Babies grew up, people died,
kisses faded, and the world started to spin
again. I finally finished my drink and walked
out of the bar. As I strolled into the new night,
I could hear a voice on the jukebox singing,
"Gee, ain't it funny how time slips away."

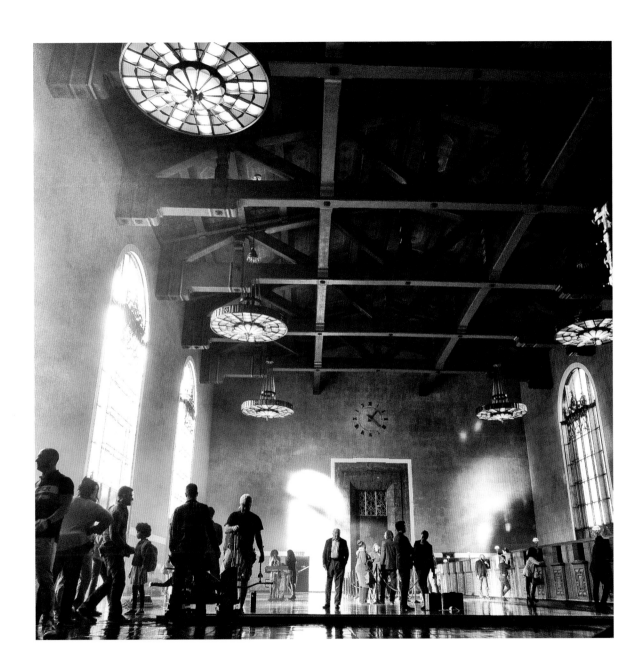

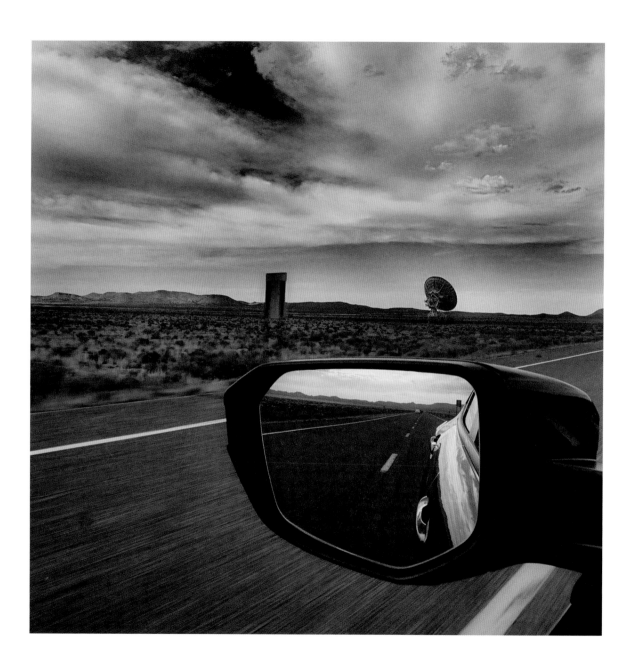

WHAT SONG
DO THEY SING?

If the universe is alive with vibrating energy that can be translated into sound, might there be a cosmic music? After all, music is really just a form of beautiful math. These were the thoughts of astrophysicist Roberta Wolfe as she drove home from her work at the radio telescopes. Midway home, she started to sing aloud in the car. The sound of the wind through the open window was like a musical chord to her song. Later she wondered: *Was there someone out there among the distant stars singing their own song?*

OUT TO SEA

When I am very old and close to the end of my life, I want my loved ones to put me in a little boat and set me out to sea. The boat will be filled with the books I never got around to reading, and a device to hear the recordings of Louis Armstrong, Bach, and the Beatles. I will bring a box of photographs of my favorite people, and a trumpet. I will cast off and drift on the ocean, reading, listening, looking out at the sky, playing trumpet, and remembering all the jokes whose punchlines I long ago forgot. As the boat becomes a tiny dot on the horizon, there will be the distant sound of music and laughter.

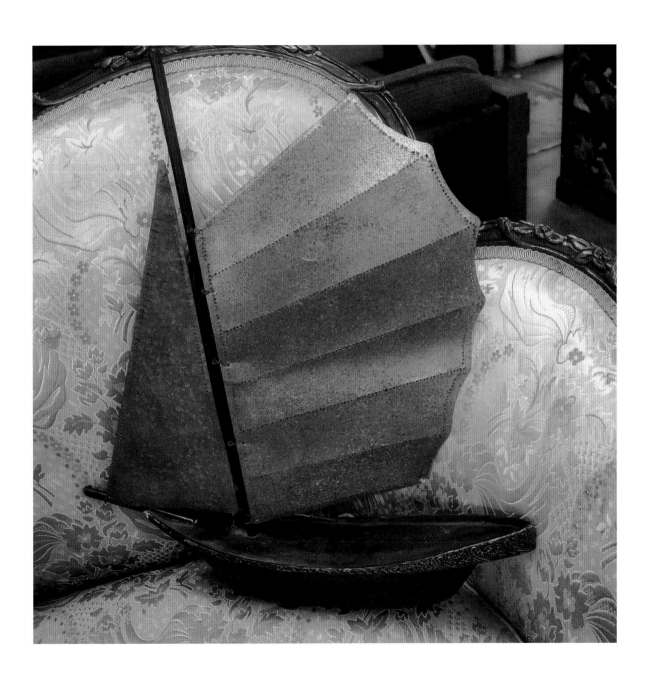

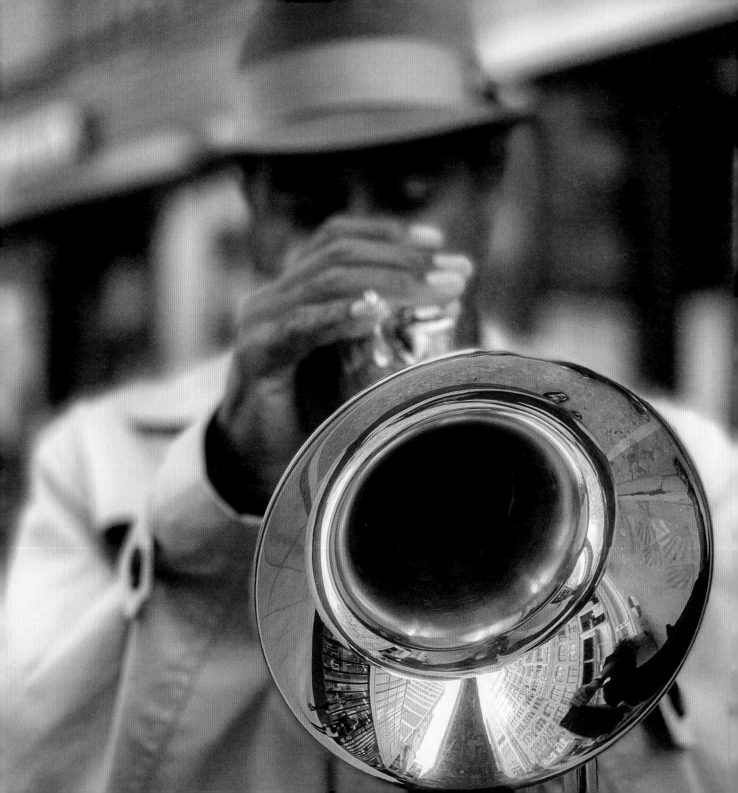

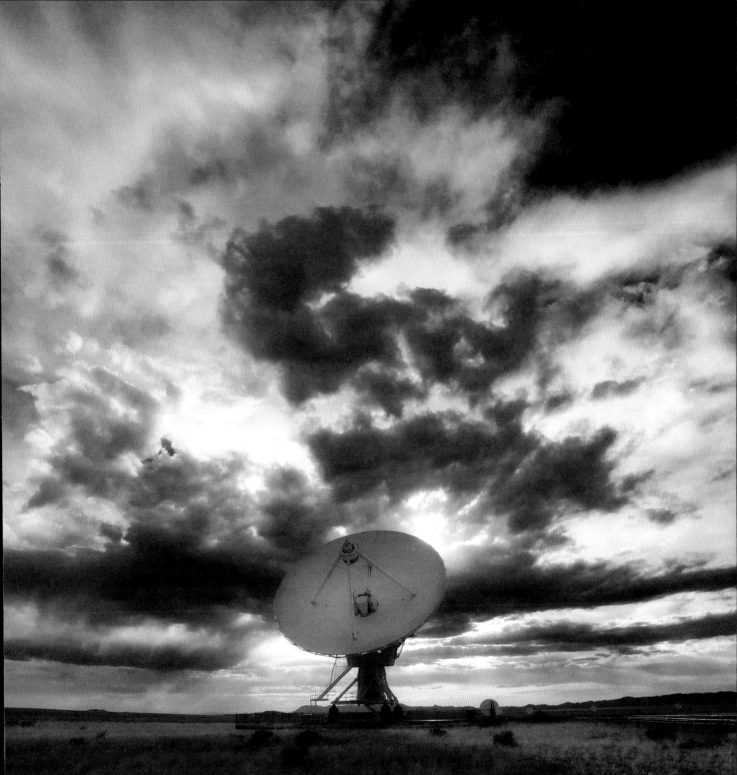

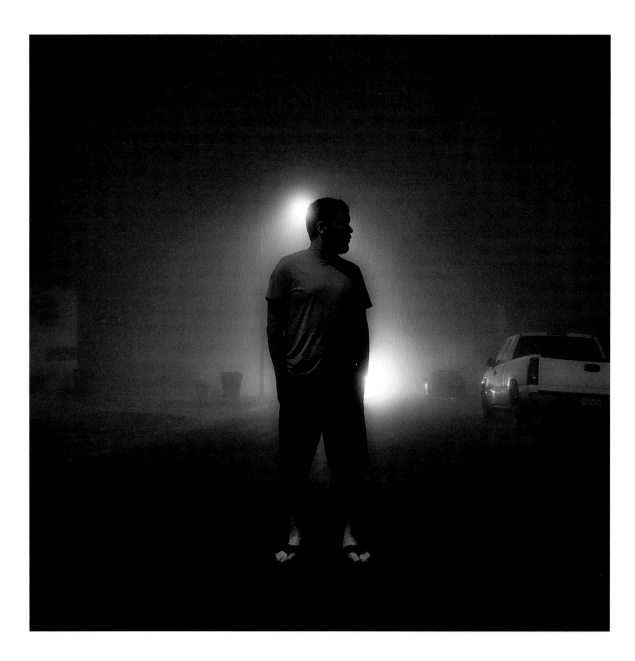

We are all just time travelers,
pausing in the beautiful now.

www.enchantedlion.com

First published in 2025 by Enchanted Lion Books,
248 Creamer Street, Studio 4, Brooklyn, NY 11231
Text & photographs copyright © 2025 by Edward Valfre
Book design: Marc Drumwright
All rights reserved under International
and Pan-American Copyright Conventions
A CIP record is on file with the Library of Congress
ISBN: 978-1-59270-377-7

Printed in Latvia by Livonia Print
Distributed throughout the world by ABRAMS, New York

First Printing

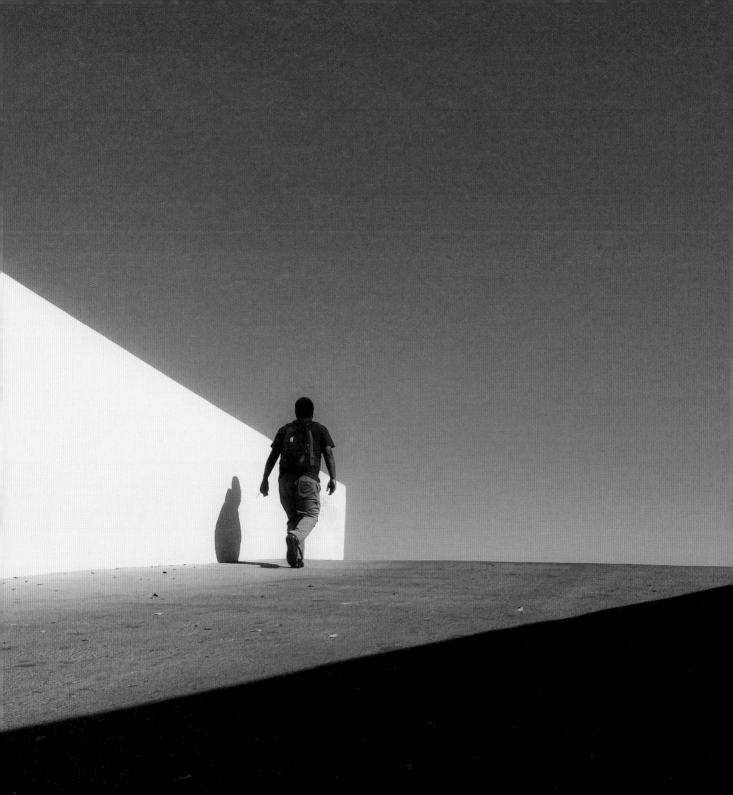

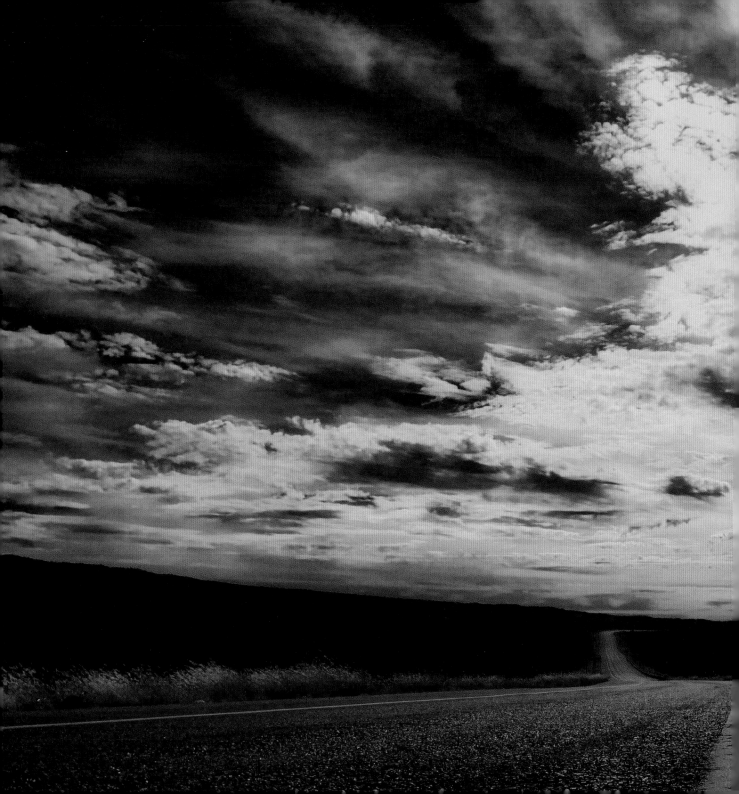